Suchan Kinoshita *the fragment in itself*

x

IKON

And now to begin as if to begin. Composition is not there, it is going to be there and we are here. This is some time ago for us naturally. There is something to be added afterwards.

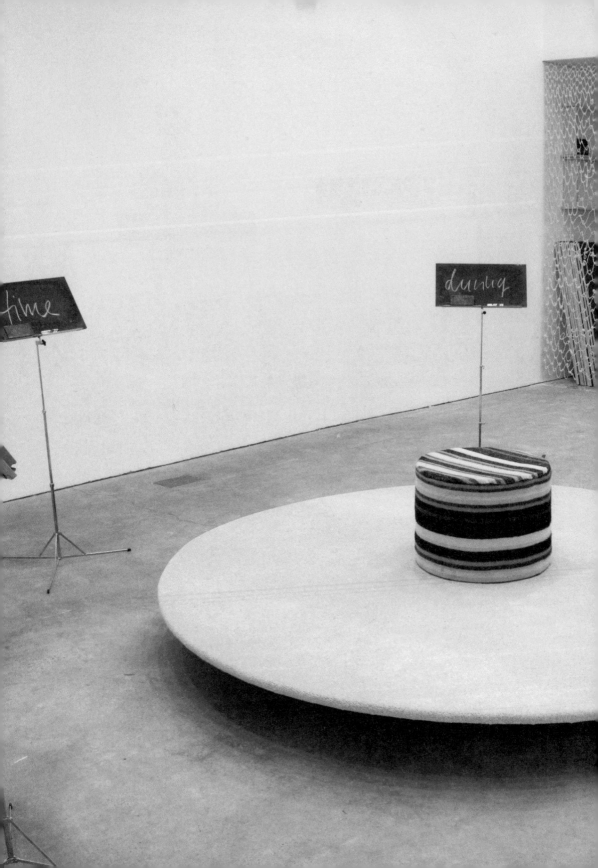

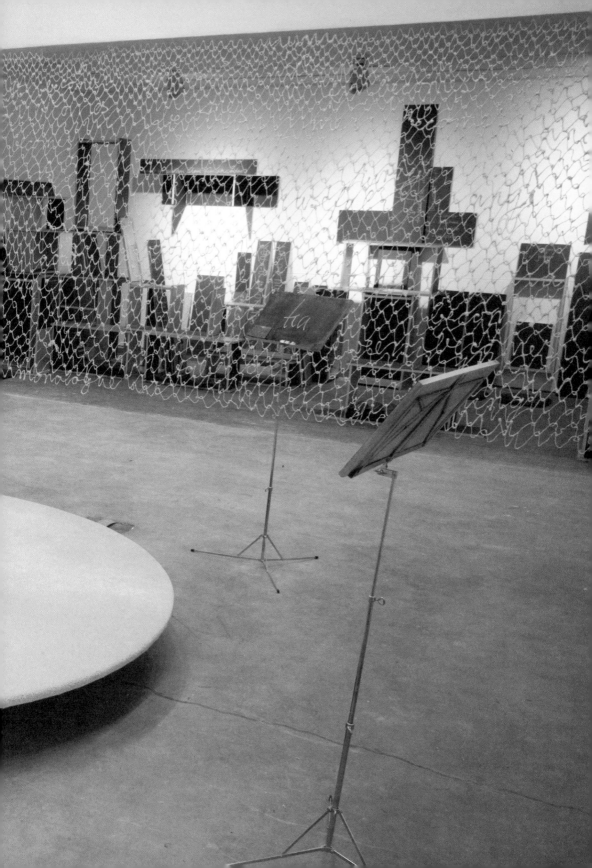

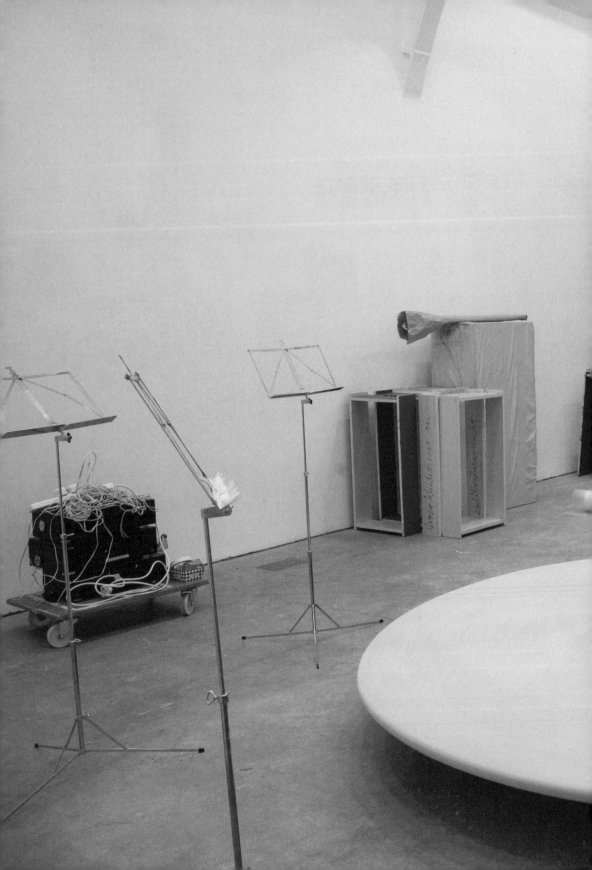

I can also give you sounds.

At a certain moment a text
A Five Act Play

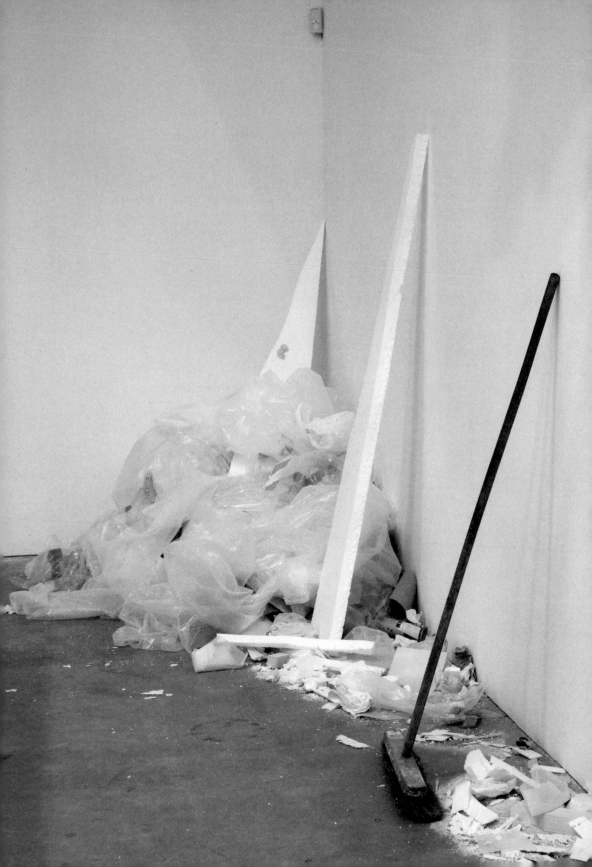

Wartende Person vor einem Passphotoapparat.
Dann kämen Photos heraus einer anderen Person.
So beginnt die Geschichte.

Person waiting in front of an instant picture booth.
Out came another person's picture.
The story began.

Naturally one does not know how it happened until it
is well over beginning happening.

It is very likely that nearly every one has been very
nearly certain that something that is interesting is
interesting them.
Can they and do they.

In my veins, in our nerve bundles, in the strands
of words that we believe to be our memories.

Does the story exist.

Person waiting in front of a railway station
slowly losing memory.
Beginning of a love story.

You shall exist, even if you take another way right
now, away from her words.

As introduction:

What Happened
A Five Act Play

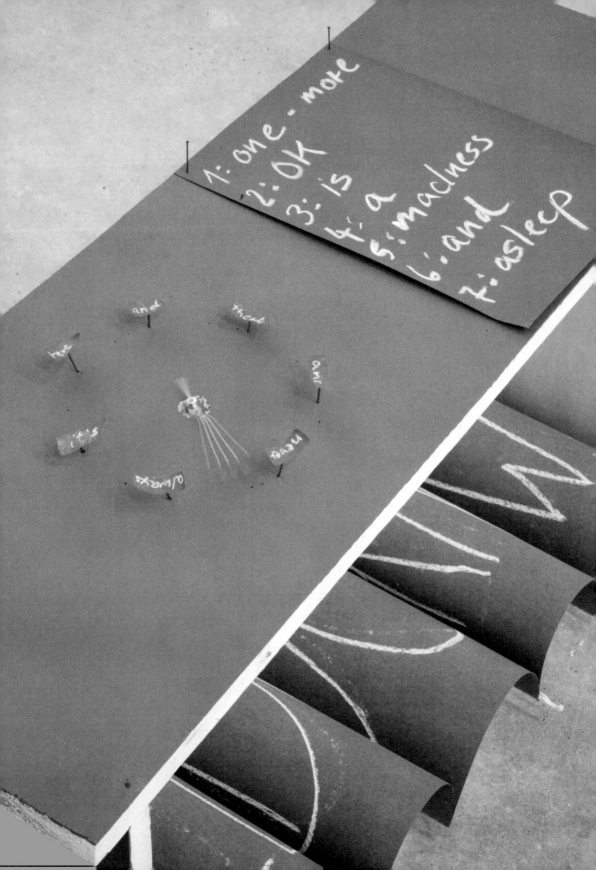

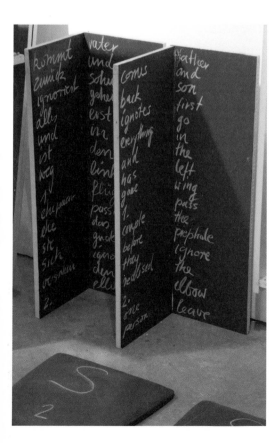

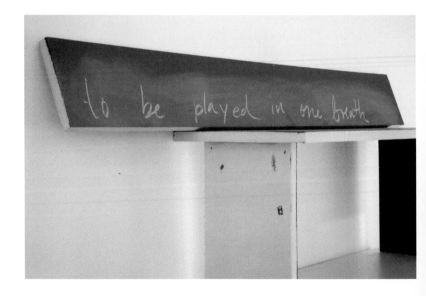

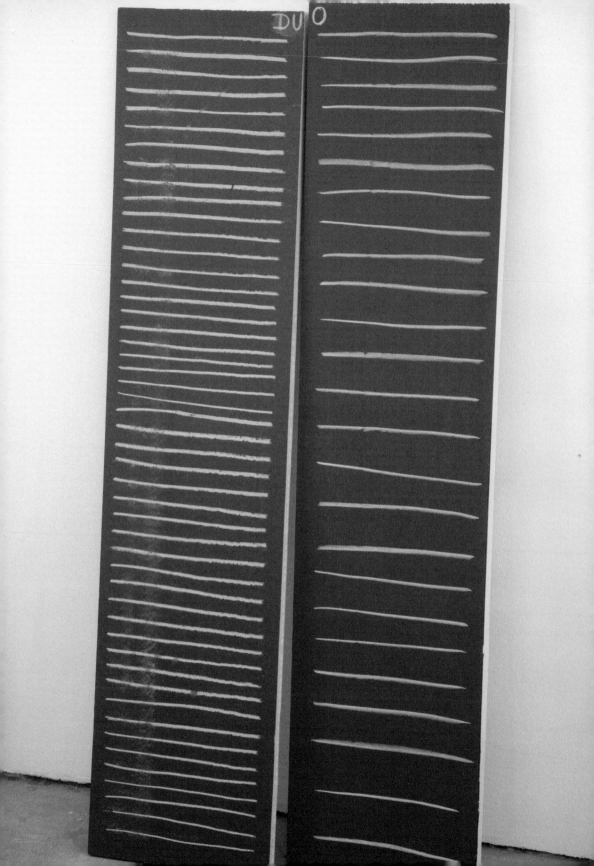

muß in einer

m gespielt werden

YOU GO

GO OUT

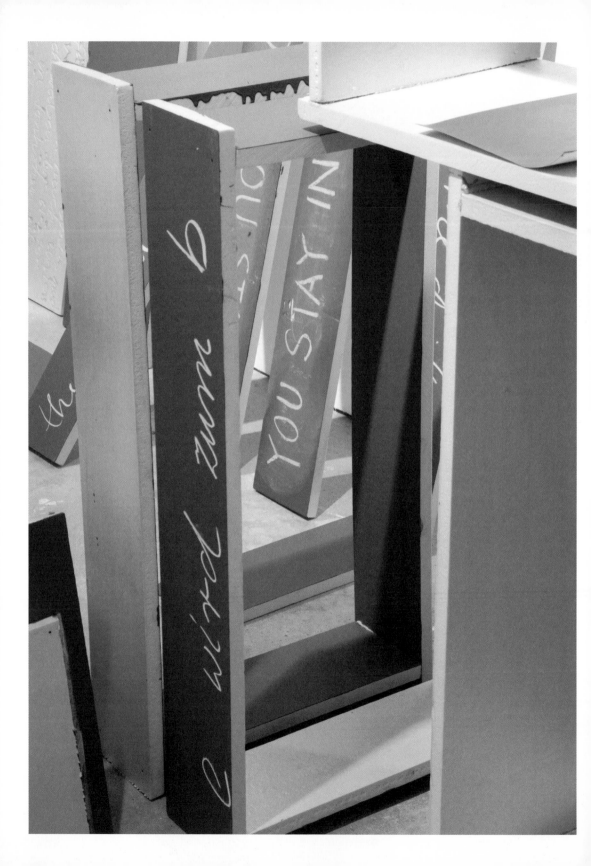

Act one
Could we not return to our previous discussion.

We fall out of our roles.
This role of the artist is to fall out of his role.
The role of the viewer is to fall out of their role.
We continuously enrol people in precisely those
enterprises of ours we don't want to be theatre.
We continuously enrol people in precisely those
aspirations of ours we want to become future.
Luckily no one is ever the policeman which we
want them to be, or the nurse, but always
deeper and less and different than that.

Just because creation doesn't allow itself to be
fixed in roles, not because it is better, or because
it is different, but maybe because this book is part
of a bid by Ikon to sniff the air, to vaporize it.
Paper is its storage place, a station in-between.

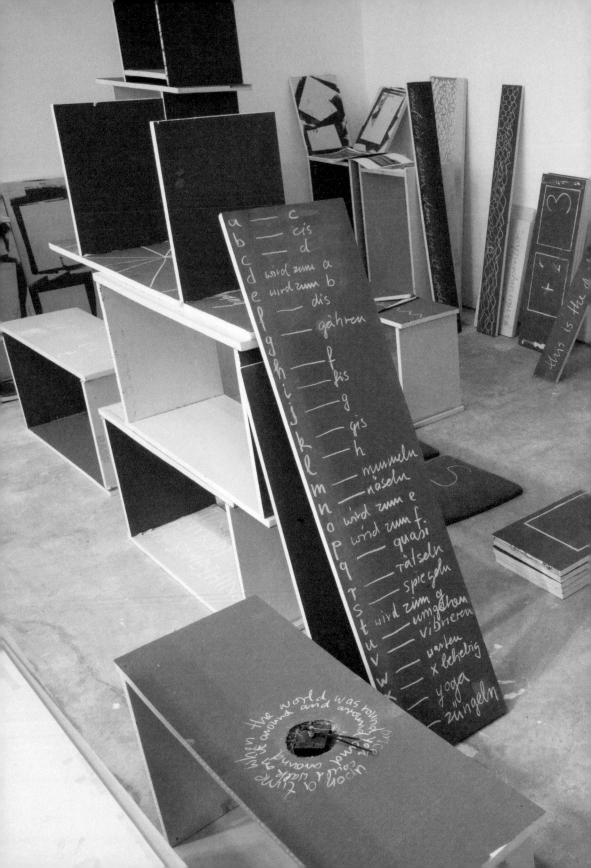

a ——— c
b ——— cis
c ——— d
d wird zum a
e wird zum b
f ——— dis
g ——— gähren
h ——— f
i ——— fis
j ——— g
k ——— gis
l ——— h
m ——— mummeln
n ——— näseln
o wird zum e
p wird zum f
q ——— quasi
r ——— rätseln
s ——— spiegeln
t wird zum g
u ——— umgehen
v ——— vibrieren
w ——— warten
x ——— x behelig
y ——— yoga
z ——— züngeln

when the world was rolling and around
upon a time

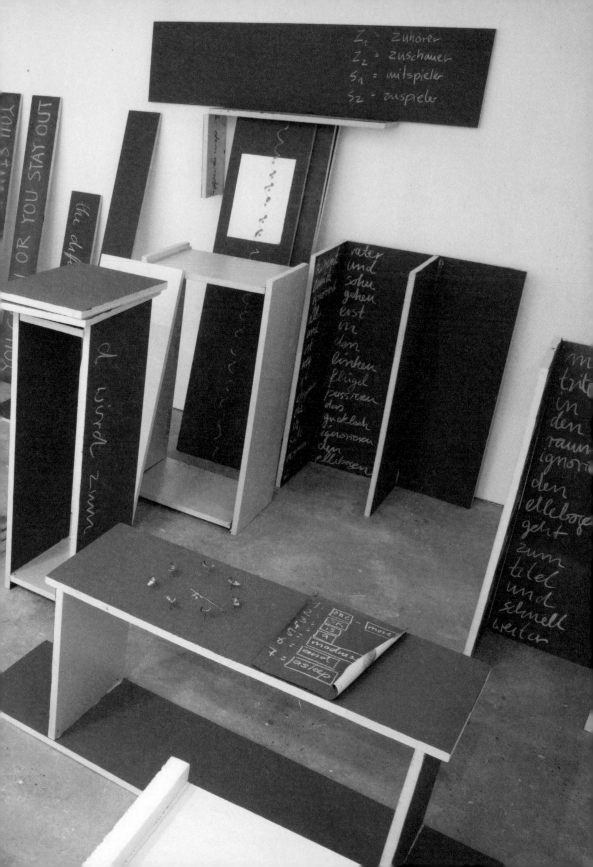

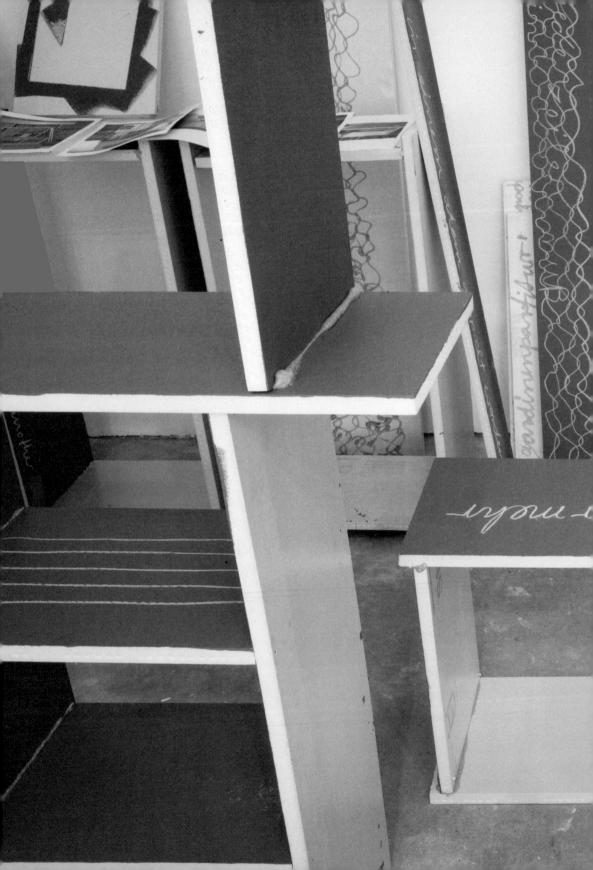

No one thinks these things when they are making
when they are creating what is the composition.
Naturally no one thinks, that is no one formulates
until what is to be formulated has been made.

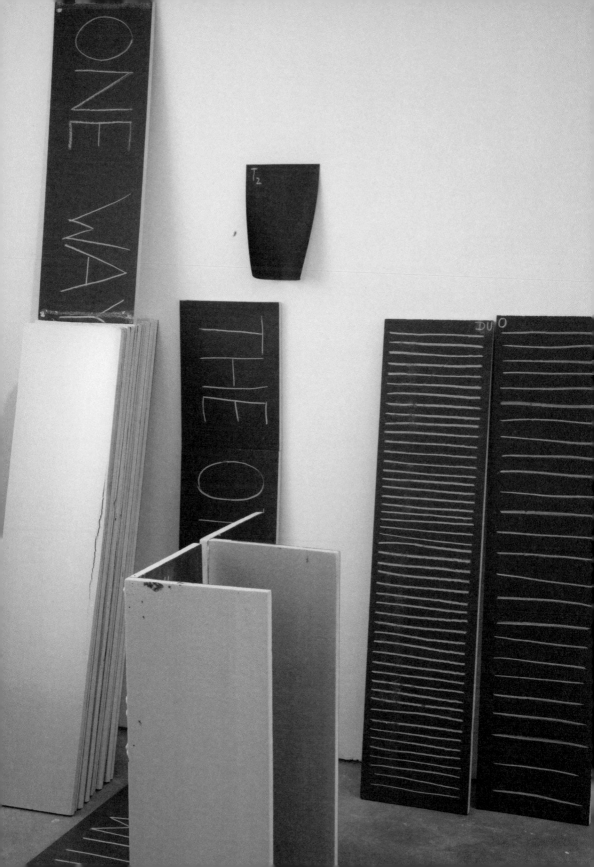

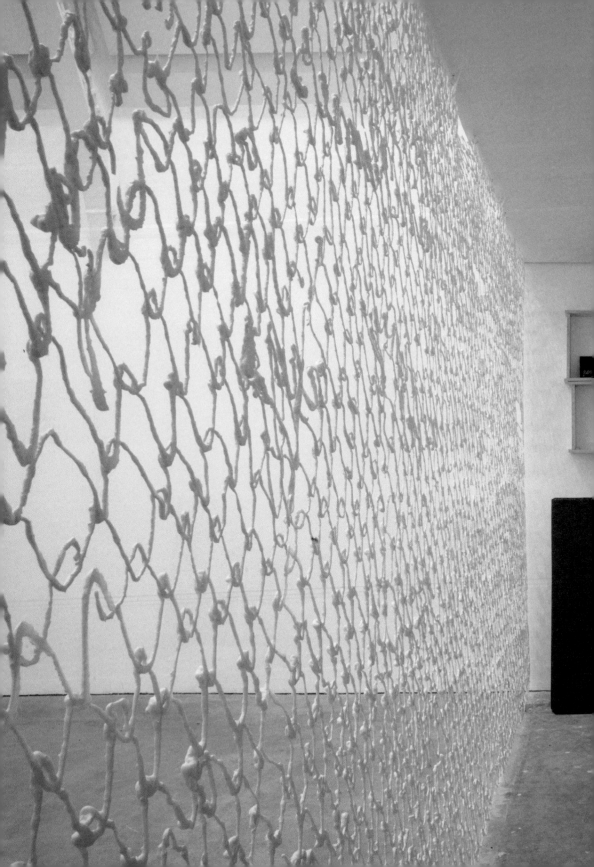

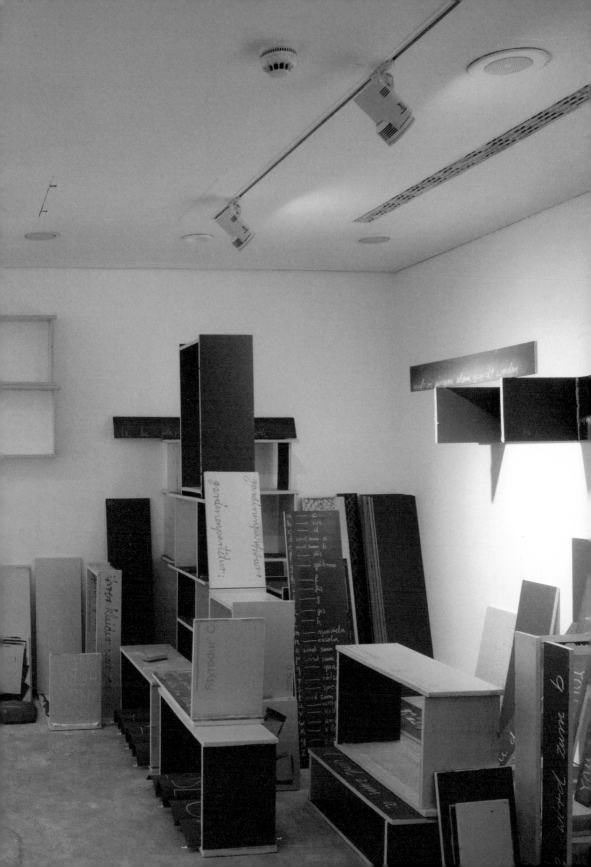

Intermezzo
We take the first train, get out at its destination,
take the first bus, get out at the first bus stop,
walk in the first pub and order a beer.
(to be continued)

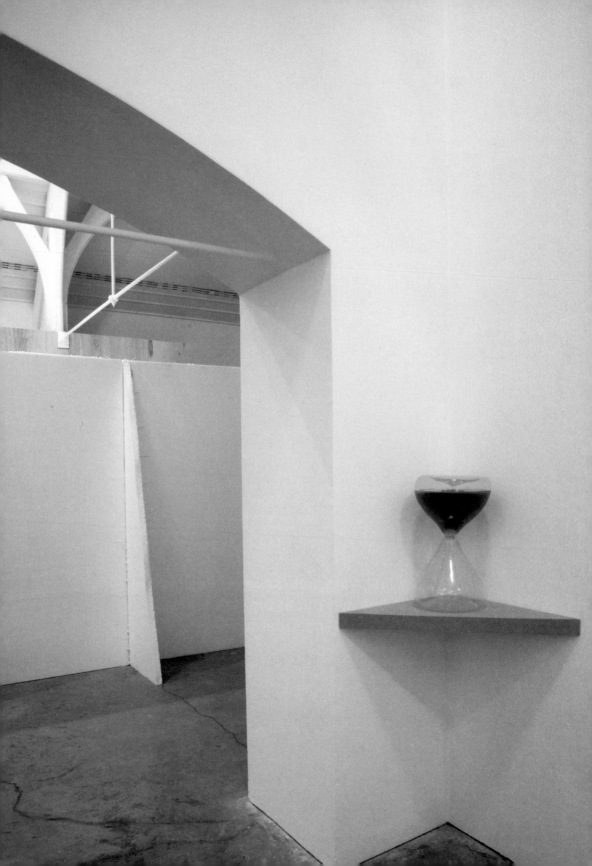

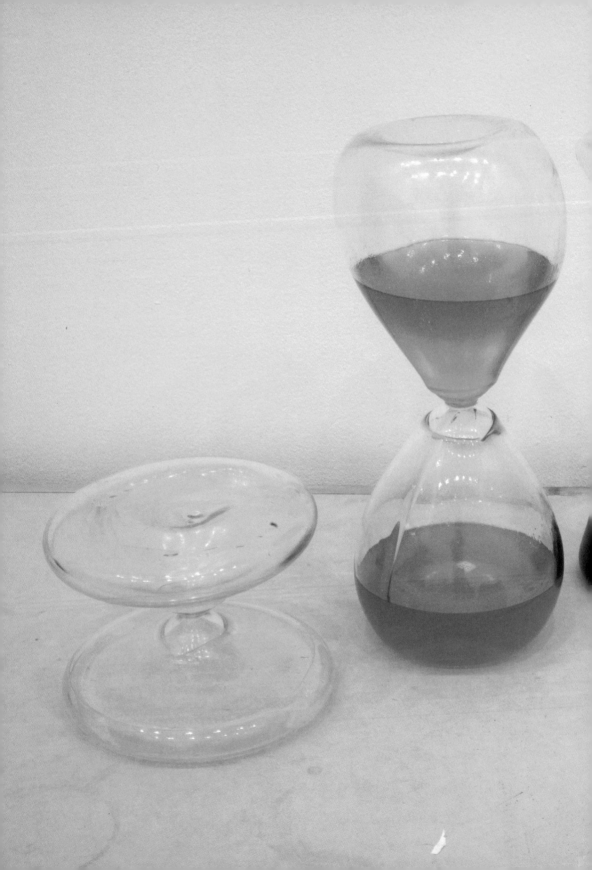

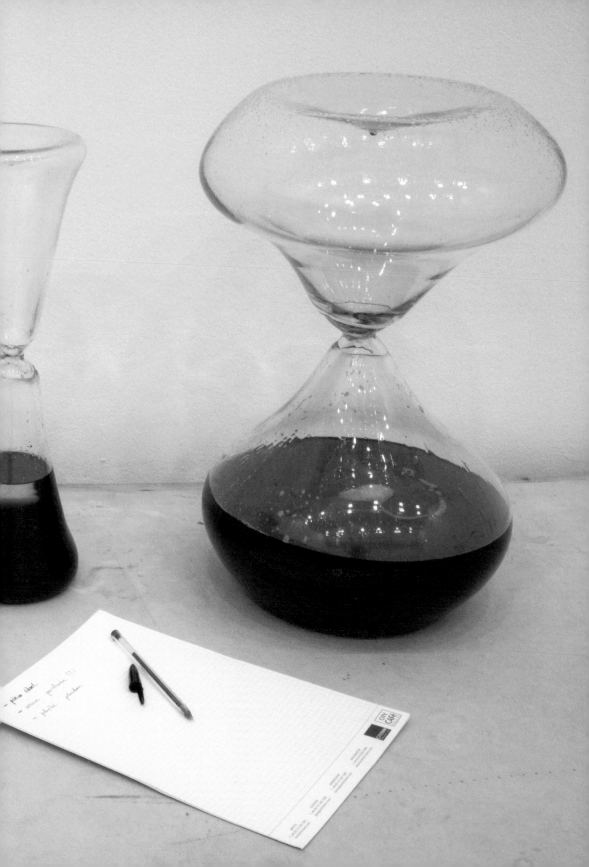

That travel agency.
The best part was that the journey didn't go anywhere.
We found out when we arrived at the same spot
after our first three hours' journey.

You:
You are rather thinking in terms of the text itself.

We always sit with three at the table.
That is a beautiful sentence, it could be the beginning.

Me:
I am thinking in terms of continuation.

The other:
The text can be the text can be a sentence.

First scene
Imagine.
Ten minutes, ten minutes ten minutes and then you
hear things you've never heard before.

Second scene
Just because you are speaking alongside/beside
each other you start speaking together.

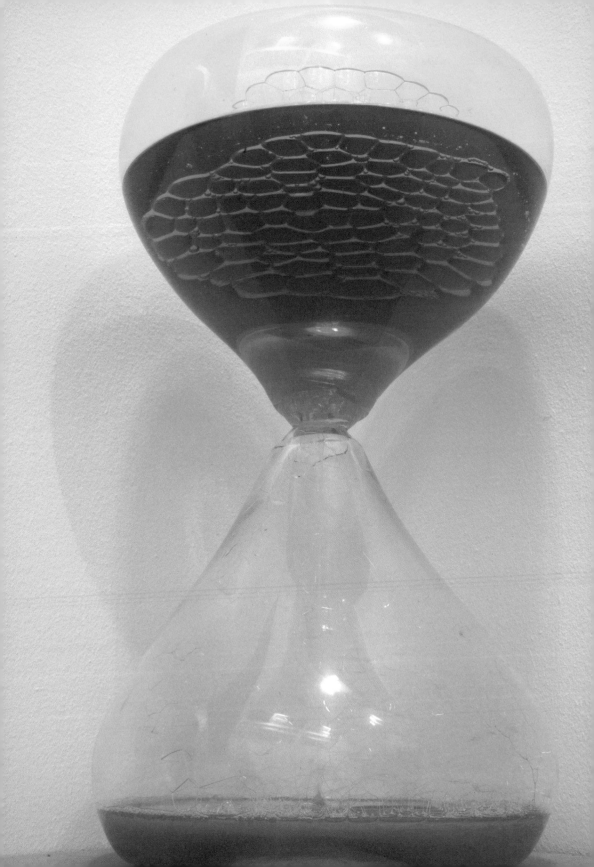

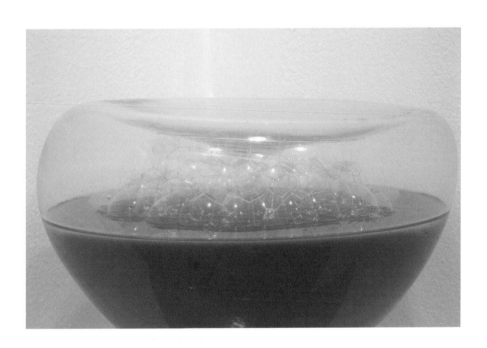

(Two)
A cut, a cut is not a slice, what is the occasion
for representing a cut and a slice. What is the occasion
for all that. A cut is a slice, a cut is the same slice.
The reason that a cut is a slice is that if there is no
hurry any time is just as useful.

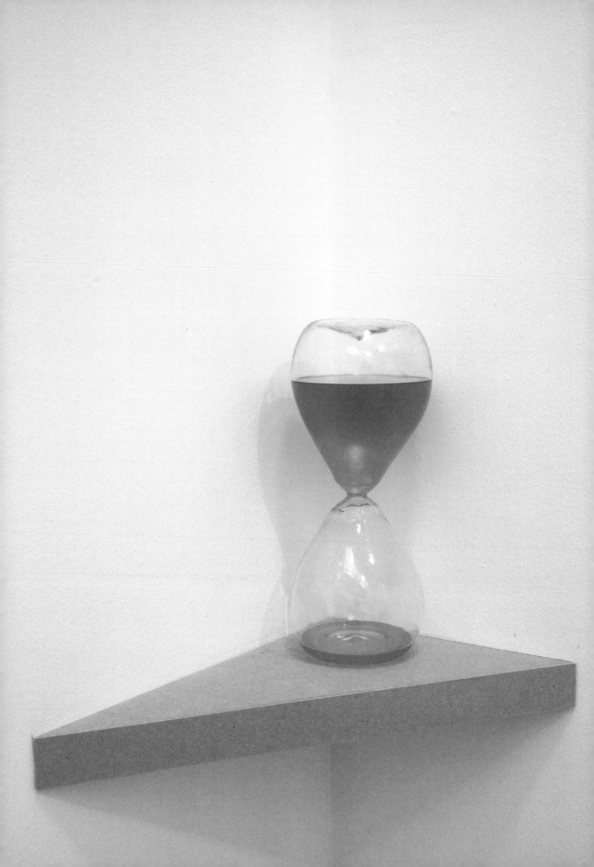

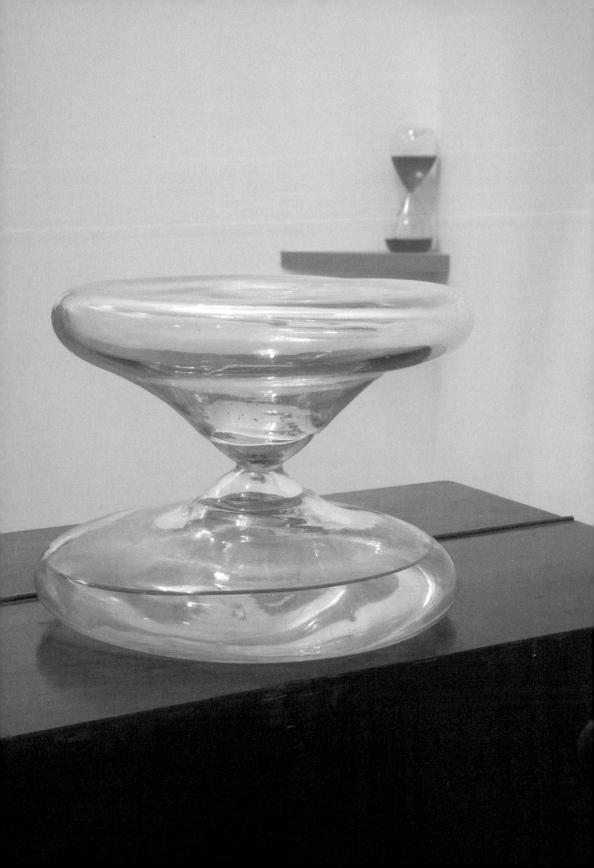

Intermezzo
The place couldn't have been better.
After a few beers and having created this place in
Brussels in a sort of ping-pong dialogue, we stepped
out of the pub and into a taxi which was standing
right in front of us.
We asked the taxi driver to bring us to that place.
(to be continued)

Naturally one does not know how it happened until it
is well over beginning happening.

Act two

They were different tribes. They did have one thing
in common, I heard from his story. The people in that
reliving of mine of his remembrance don't speak to
each other the way we do in North Western Europe.
They don't speak in our remarkably affected
construction-like manner, whereby we exclude
almost the whole world. The talking was a talking
that was not practical for activists. Everyone said
what was bothering him or her, the water supply,
minor and major urgencies, activism too. Why not.
For hours on end, until the conversation became
a conversation by itself.

From such talk something approaching a consensus
can grow, or something can grow which coheres in
the way the world coheres, or an image of the
world coheres.

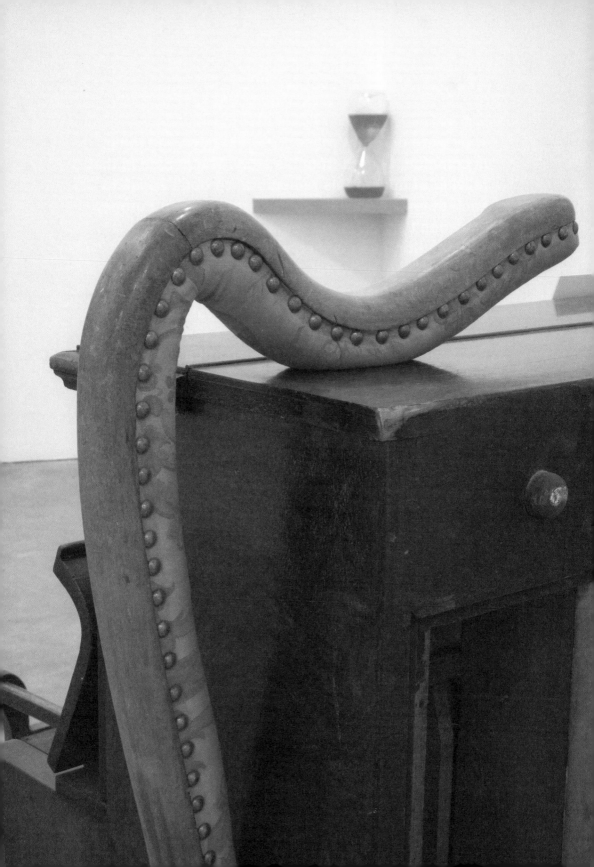

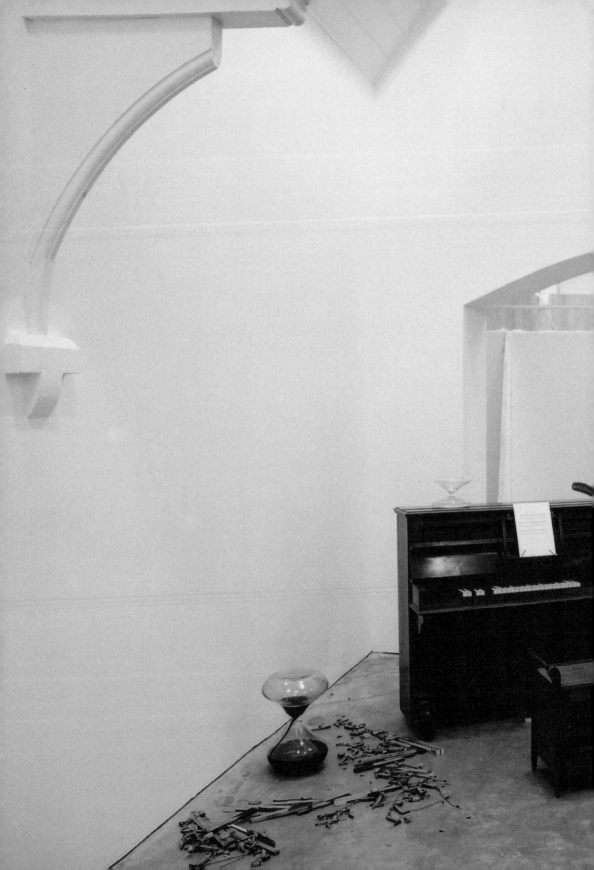

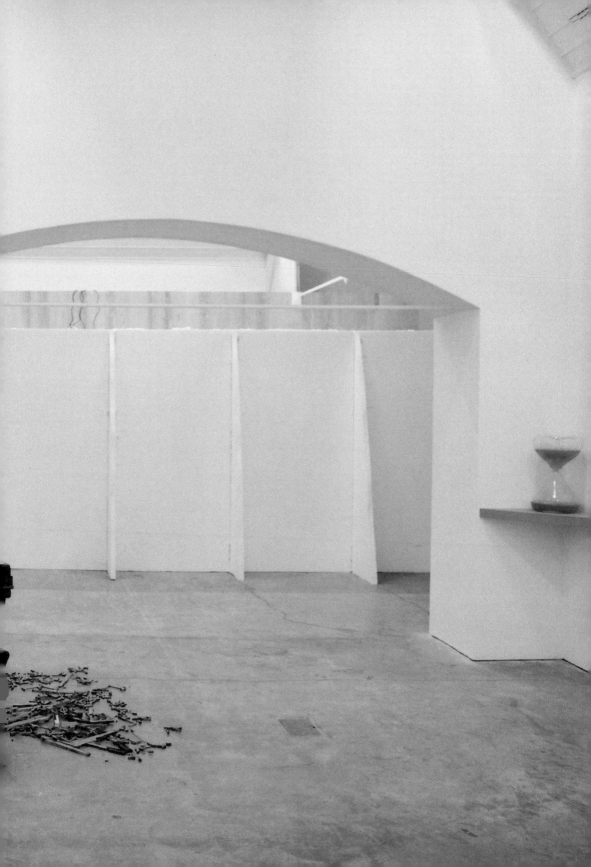

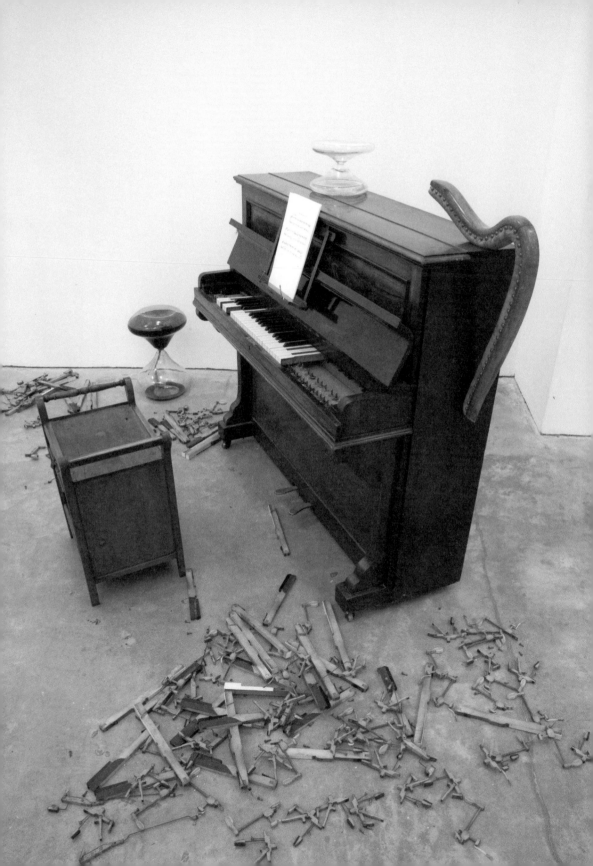

35. Das"Fragment an sich"

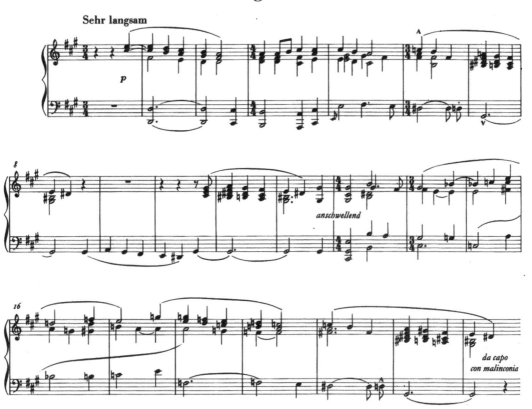

F. Nietzsche

The night-watchman in prison checking the CCTV monitor

0:00 Cees seems to be sleeping
0:30 Cees seems to be sleeping
1:00 Cees seems to be sleeping
1:30 Cees seems to be sleeping
2:00 Cees is lying under his blanket and seems to be sleeping
2:30 Cees seems to be sleeping
3:00 Cees seems to be sleeping
3:30 Cees didn't move but seems to be sleeping
4:00 Cees seems to be sleeping
4:30 Cees seems to be sleeping
5:00 Cees seems to be sleeping
5:30 Cees seems to be sleeping
6:00 Cees seems to be sleeping
6:30 Cees seems to be sleeping

first scene
(stays empty)

I can give you silences in between

Intermezzo
After one hour of driving and not finding the place,
but meanwhile having seen most of Brussels and
much more, the taxi driver suddenly stopped at
a corner, and called all his colleagues on duty for
help by radio control.
(to be continued)

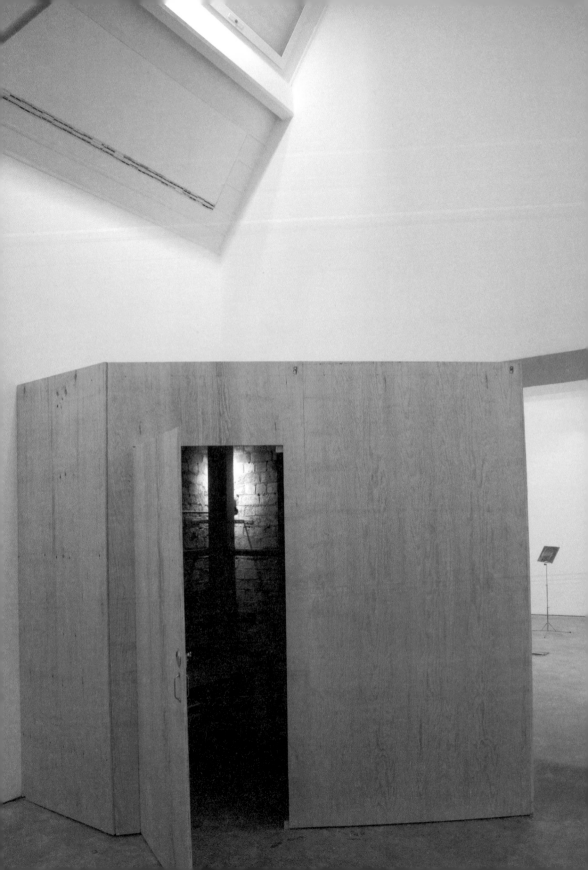

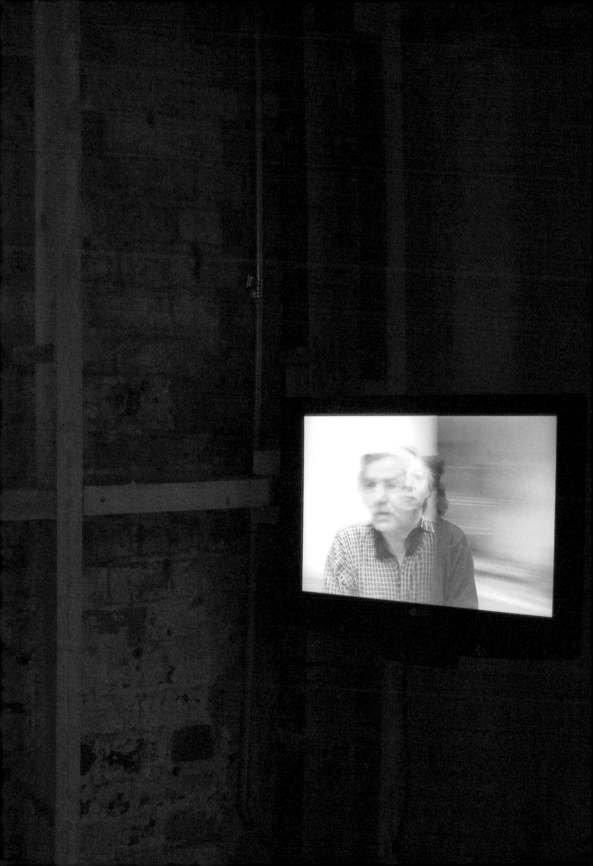

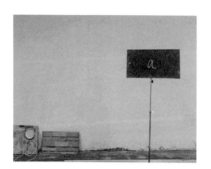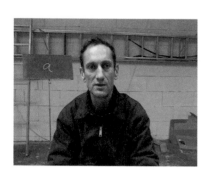
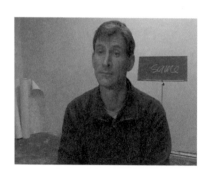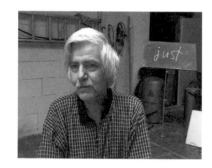
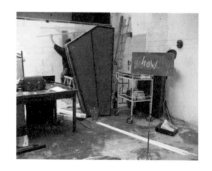

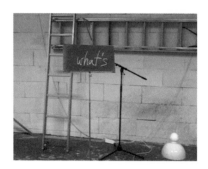

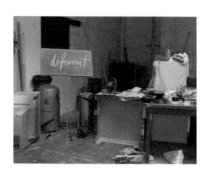

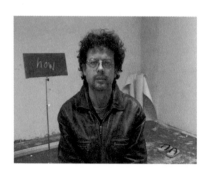

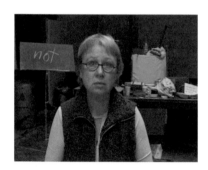

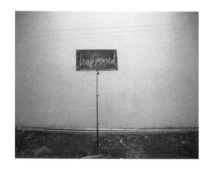

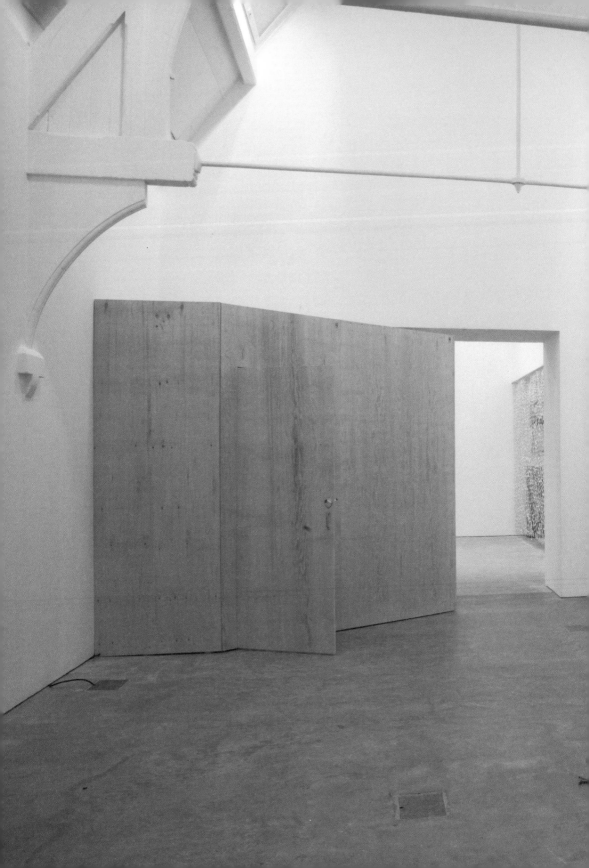

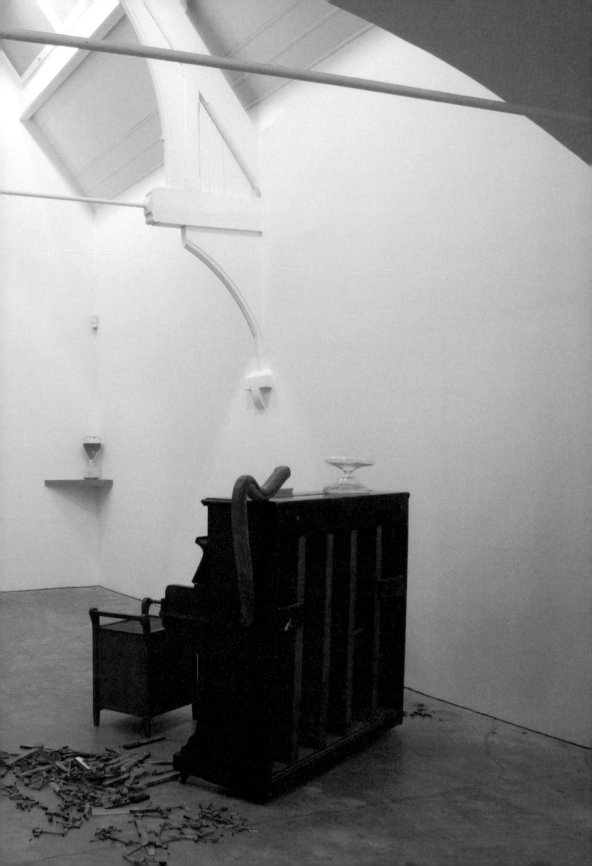

We leave the scrapping to the editor.
Would you like me to become multi-coloured.
The text is now open between two You Tube videos
in which you see the charlatanesque political leader
of the local extreme right party in Antwerp land on
his face. He and his party recently saw their fantasy
of an increasing electoral growth flop with a majority
of people.

'Man, man, man, how is this possible?' he says. 'Zero
zero', he tries to make of it.

But mainly, after that bad taste, the music works
even stronger. A few lines on I am taken out of that
story by the rock group dEUS, which, with a concert
for 100,000 people in four cities one week before
the elections, formed the icebreaker of a liberating
cultural space against fatalism and desperation.
'Instant Street' I hear.

Does that have anything to do with this text.

Should we not rather search for the "nebenans"
rather than the scrappings.

At the same time a song called 'Suds & Soda' is on
but that is not part of this story. It falls outside of the
scene, outside of the silence of the book, outside of
the subject of the book, too, it falls on the table
upon which lies the book. That table has an imitation
wooden top.

There is singularly nothing that makes a difference a difference in beginning and in the middle and in ending except that each generation has something different at which they are all looking. By this I mean so simply that anybody knows it that composition is the difference which makes each and all of them then different from other generations and this is what makes everything different otherwise they are all alike and everybody knows it because everybody says it.

Intermezzo
We received a sort of radio cacophony on angels in Brussels:
"…..which angel, the one with the big wings,
angels ….. there are these small ones in a row,
…..the black one, you mean that one that had fallen
…..crashed…….. those standing in groups….. that big
one with open arms…."
(to be continued)

chinese whisper
téléphone arabe
stille post.

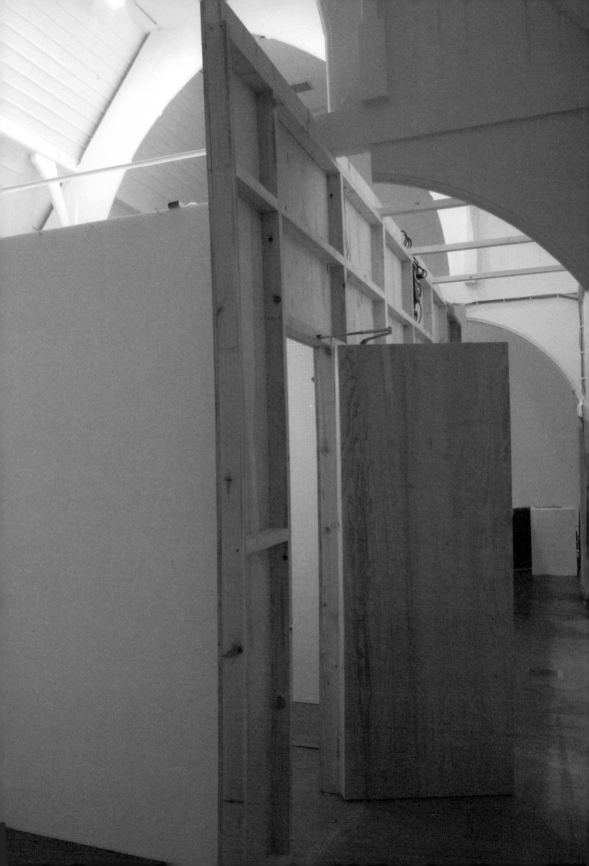

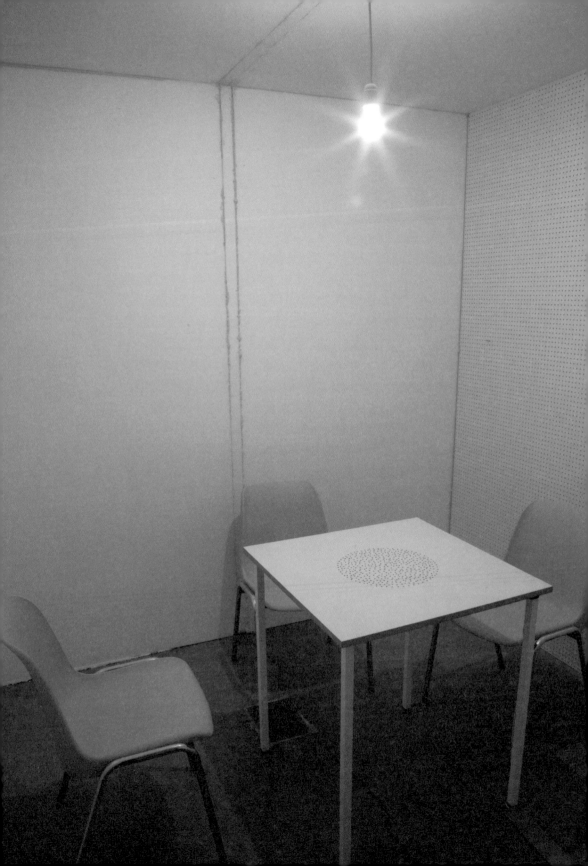

An old guy sitting in his little shop in order to sort out his things, things to be invented for the shop. The shop is not only a shop is a storage is a tiny space where it's hard to move yourself and the things as similar as they can become. The movements slow and old and without audience besides one who likes to be near one who has found the way to be watching. Not really watching but rather realizing a page turning into some stripes and the stripes getting numbers and the numbers ending up standing in an empty aquarium and those can make you win a fish.
The fishes don't realize anything but seemed to be watching. It is slow.

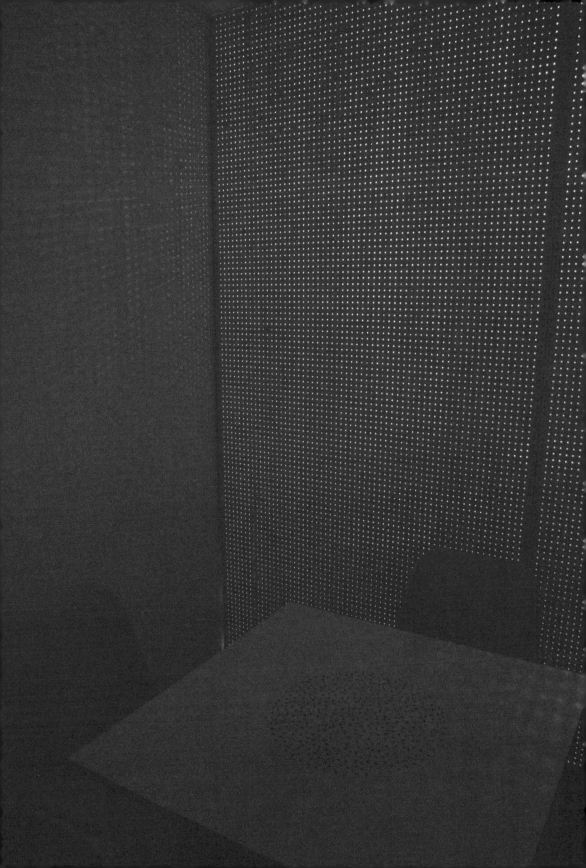

Rather a name for a journey,
a name which gives colour.
We shall go to Rome,
we shall go to Zanzibar.
A name, a title, maybe the title comes in between,
while he gently takes the cigarette packet in his
hands:

'living kills'

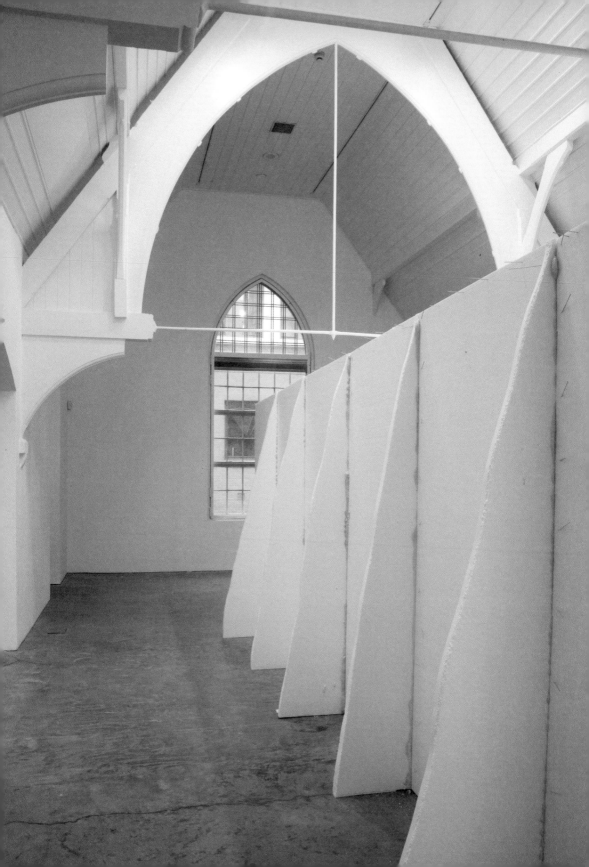

No grand cohesive story, more the appreciation of fragments which at a certain point become important.

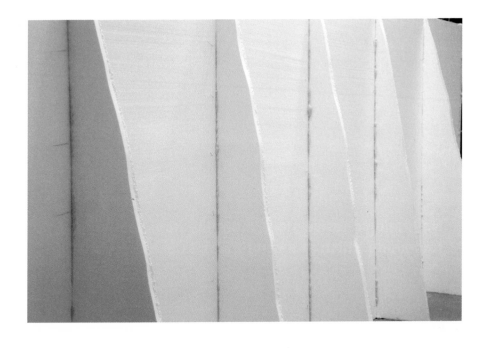

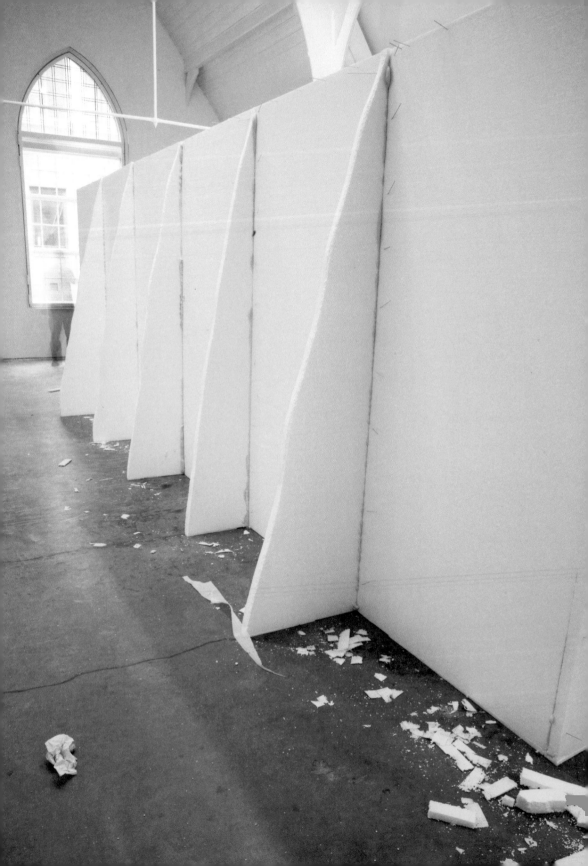

At the reception there was a scientist who interpreted the prepared piano piece by Nietzsche, 'the eternal return', as follows: Music is composed of interruptions. This piece that Nietzsche as composer intended to be resumed into eternity, so resumes interruptions, fragments.

I had always seen music as continuity, which is incomplete.

Bits of text which find their moment
Bits of text which miss the moment
Bits of text which know no moment
Bits of text which have been nicked
Bits without text
and texts without bits.

Or as they say in Germany:
Fritten mit ohne Alles

Yes it could be that I want it to be multi-coloured.

removed: completely forgotten
removed: it flows
removed: un
removed: not
removed: creativity
added: c
removed: maybe
removed: an herbarium
removed: so
removed: when our friend went to speak with the
 various tribes with his activist friends of the American
 Indian Movement, that was not self-evident
removed: a
removed: and we then stick the remaining subject
 in the straitjacket of a logic of arguments, the machine
 of our thought
removed: thereby also possibly a side by side
removed: grow a consensus, or can
removed: takes cigarettes in his hands
removed: reprisals, editing
removed: go-betweens
removed: who
removed: print, read
removed: can be remaining silent
removed: sense

Naturally one does not know how it happened
until it is well over beginning happening.

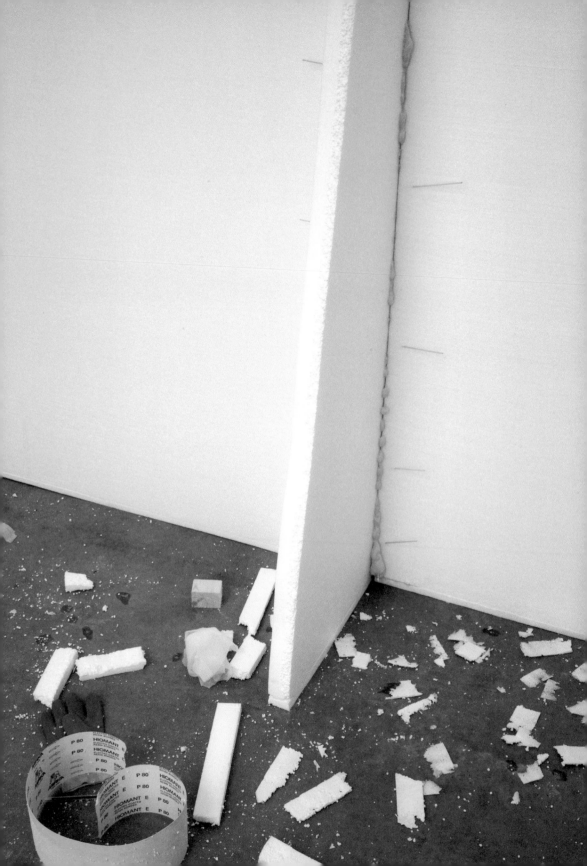

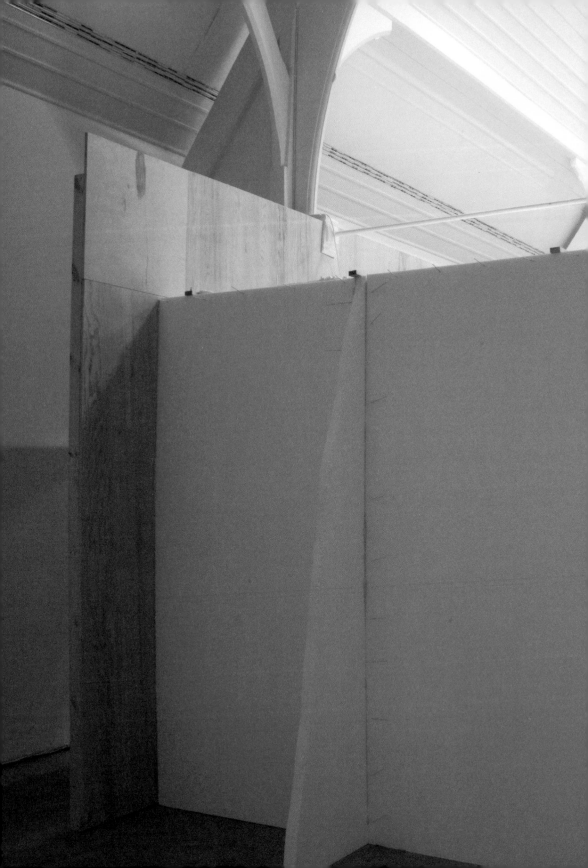

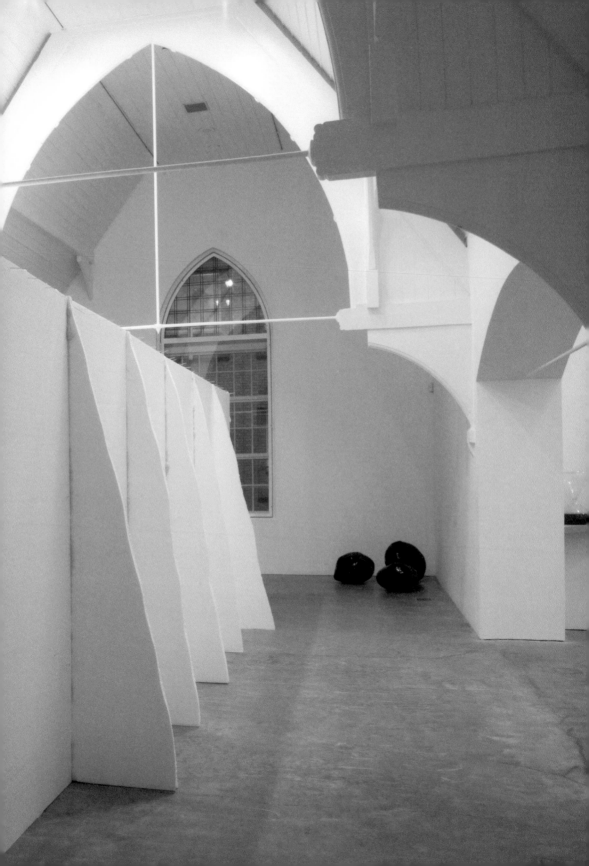

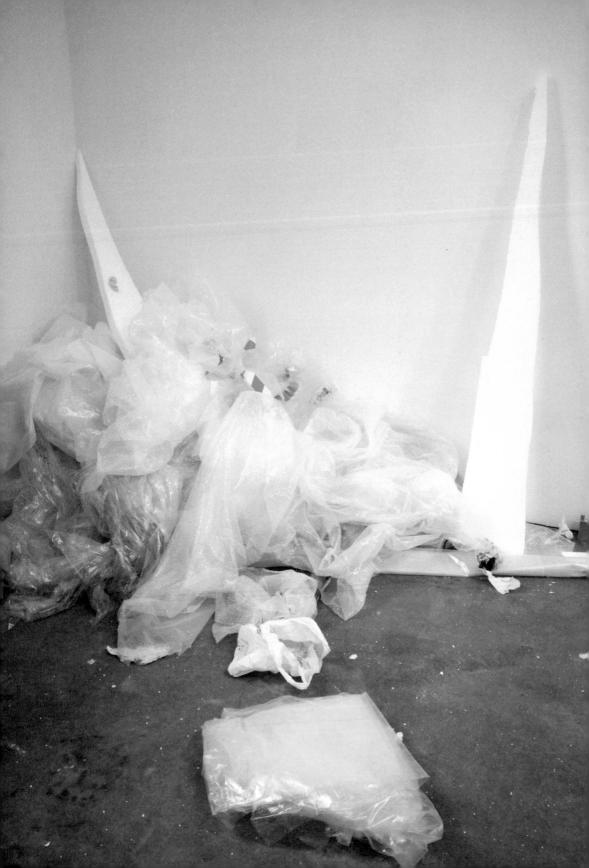

Third scene
What do you want.

Silence is in blessing and chasing and coincidences
being ripe. A simple melancholy clearly precious and
on the surface and surrounded and mixed strangely.
A vegetable window and clearly most clearly
an exchange in parts and complete.

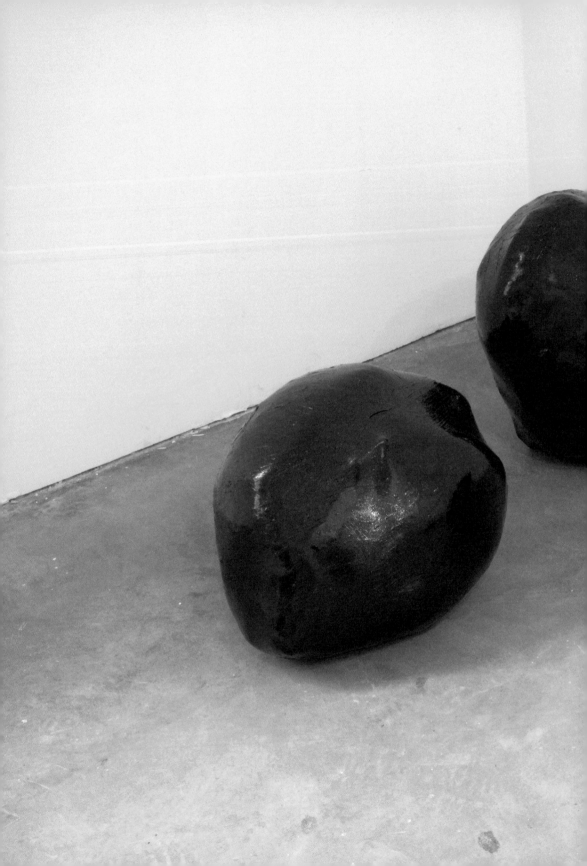

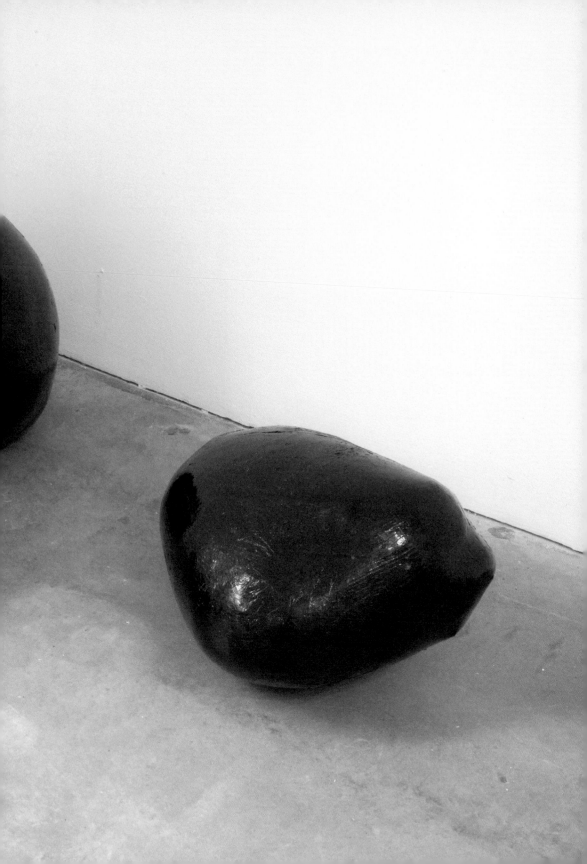

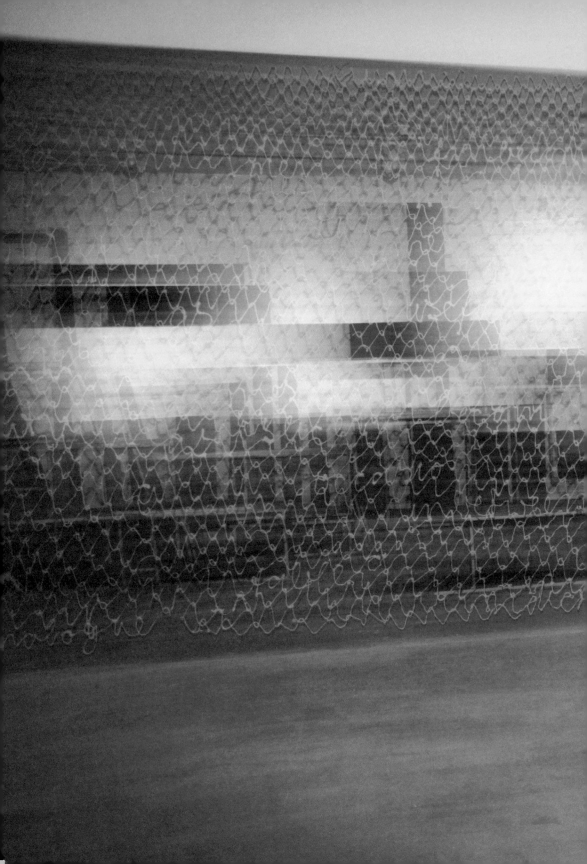

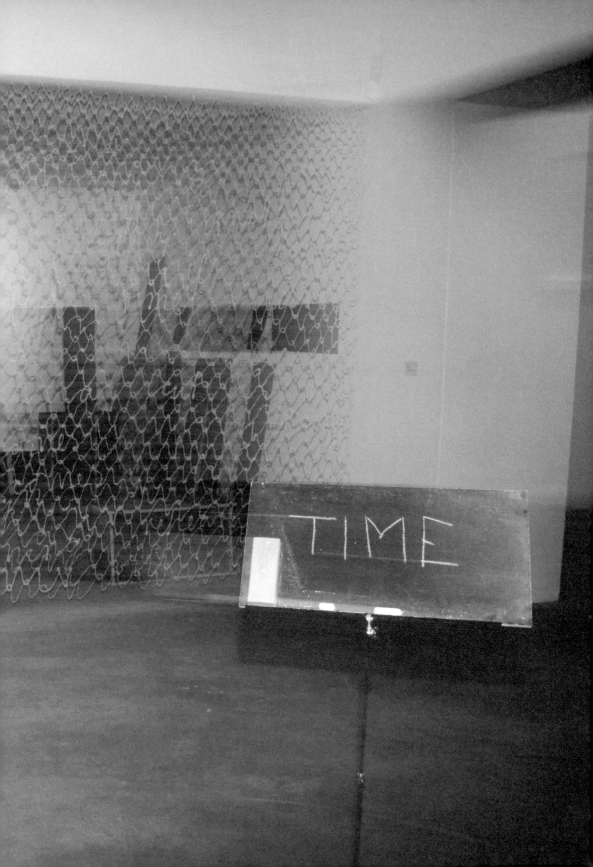

It is the half-light and the half-shadow more than the dust which isn't really there. It is the night out of which it comes when the switch is switched on and when the scene becomes scenic.

I always hated the moments when the light was switched on when I just had gotten into these endless sessions taking place in the darkness in that metal piece above my lamp.

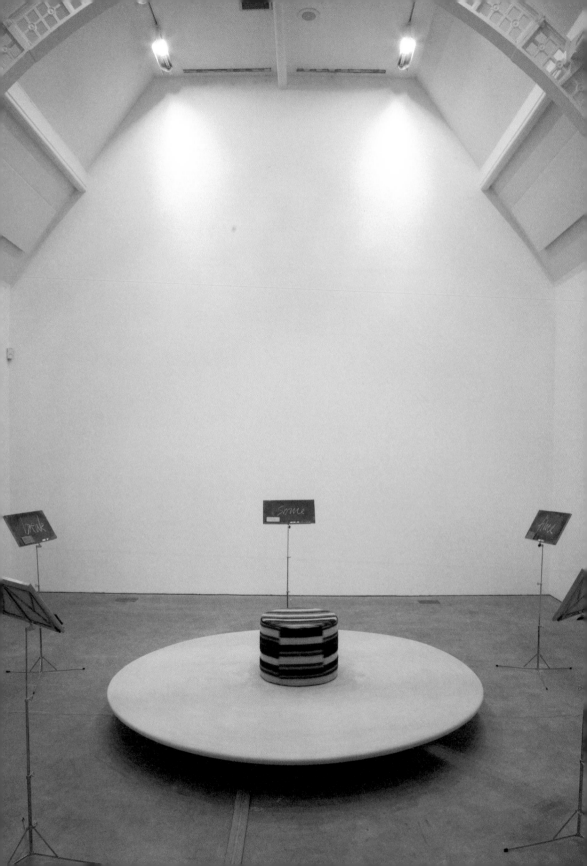

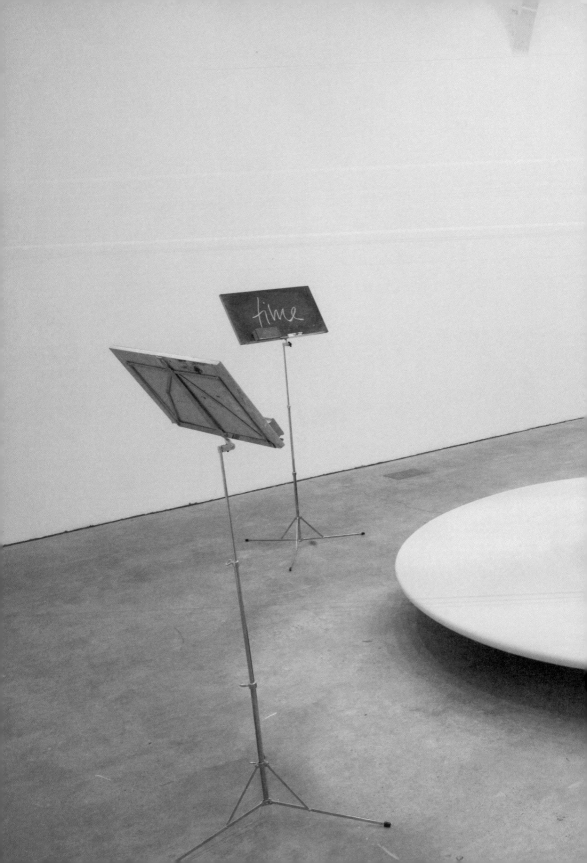

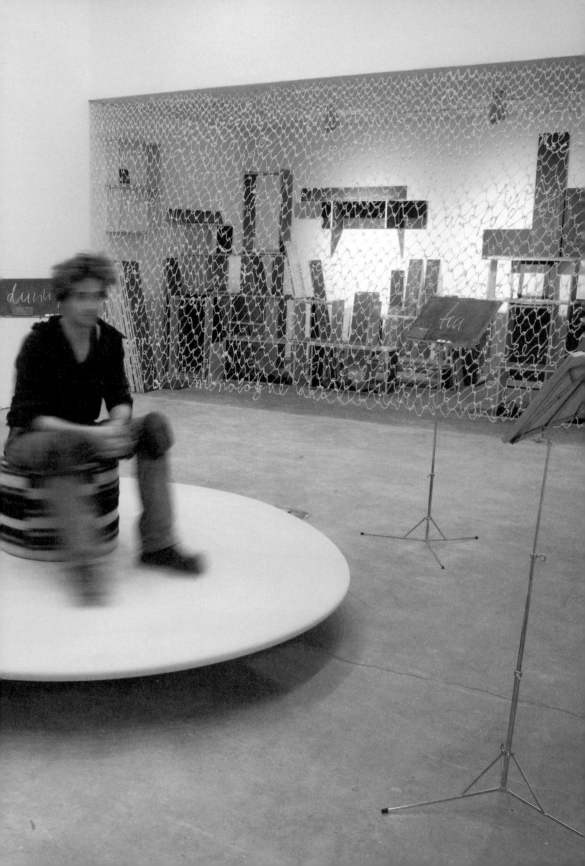

List of works

inbetweening
2004
Rotating platform with music stands and boards
Dimensions variable

depot des mots
2005
Inscribed panels and polystyrene curtain
670 x 350 x 270 cm

Das Fragment an sich
2006
Prepared piano with stool, clock and furniture fragmant
Dimensions variable

it must have been thursday afternoon
2004
Pegboard, polystyrene, desks, chairs, sound and satay sticks
850 x 290 x 260 cm

minutes of monologue
2004
Plywood cabin and DVD
290 x 270 x 245 cm

clocks
200 – 2005
Glass and various liquids
21 x 22 x 16 cm; 29 x 29 x 50 cm; 29 x 29 x 50 cm;
29 x 29 x 47 cm; 16 x 15 x 44 cm

isofollies
2006
Wrapped rubbish from exhibition
60 x 47 x 57 cm; 65 x 43 x 43 cm; 60 x 50 x 39 cm

Published on the occasion of Suchan Kinoshita *Das Fragment an sich (The fragment in itself)*, exhibition, Ikon Gallery, Birmingham 29 November 2006 – 21 January 2007. Curated by Jonathan Watkins, assisted by Diana Stevenson

ISBN 9781904864271

Ikon Gallery
1 Oozells Square, Brindleyplace, Birmingham, B1 2HS
t: +44 (0) 121 248 0708 f: +44 (0) 121 248 0709
http://www.ikon-gallery.co.uk
Registered charity no: 528892

Text written in collaboration between Bart de Baere and Suchan Kinoshita. Text fragments from Gertrude Stein, *Composition as Explanation* (1926) and *What Happened* (1922), and Peter Handke *Das Gewicht der Welt* (1977)

Edited by Jonathan Watkins
Designed by Herman Lelie
Photography by Jerry Hardman-Jones
Printed by Connekt Colour, UK

Distributed by Cornerhouse Publications
70 Oxford Street, Manchester, M1 5NH
publications@cornerhouse.org
t: +44 (0)161 200 1503 f: +44 (0)161 200 1504

With thanks to Anne, Martin, Harriet and Francis Cody for the piano, and Sarah Oliver for the piano stool

All works courtesy of the artist, Galerie Nadja Vilenne and Ellen de Bruijne Projects

Ikon gratefully acknowledges financial assistance from Arts Council England, West Midlands and Birmingham City Council

This exhibition is supported by
The Henry Moore Foundation and
The Mondriaan Foundation

Ikon Staff

Mike Buckle, Assistant (Ikon Shop)
James Cangiano, Education Coordinator
Rosalind Case, PA/Office Manager
Zoe Charaktinou, Gallery Assistant
James Eaves, Fundraising Manager
Richard George, Manager (Ikon Shop)
Graham Halstead, Deputy Director
Gemma Hawkes, Gallery Assistant
Matthew Hogan, Facilities Technician (AV/IT)
Helen Legg, Curator (Off-site)
Emily Luxford, Marketing Assistant
Chris Maggs, Facilities Technician
Deborah Manning, Visitor Assistant
Jacklyn McDonald, Visitor Assistant
Natalia Morris, Visitor Assistant
Michelle Munn, Visitor Assistant
Esther Nightingale, Education Coordinator (Creative Partnerships)
Matt Nightingale, Gallery Facilities Manager
Melissa Nisbett, Marketing Manager
Sarah Oliver, Visitor Assistant
Jigisha Patel, PR and Press Manager
Anna Pike, PR and Press Officer
Nigel Prince, Curator (Gallery)
Xenia Randle, Programme Assistant
Amy Self, Visitor Assistant
Kate Self, Education Coordinator/Gallery Assistant
Nikki Shaw, Education Coordinator
Richard Short, Technical and Office Assistant
Joanna Spencer, Visitor Assistant
Diana Stevenson, Exhibitions Coordinator
Dianne Tanner, Finance Manager
Claire Turner, Curator (Education and Interpretation)
Jonathan Watkins, Director

Birmingham City Council

Mondriaan Stichting (Mondriaan Foundation)

The Henry Moore Foundation